Paige Tate & Co.

Copyright © 2023 Alli Koch

Published by Paige Tate & Co.
Paige Tate & Co. is an imprint
of Blue Star Press
PO Box 8835, Bend, OR 97708
contact@paigetate.com
www.paigetate.com

Illustrations by Alli Koch

ISBN: 9781958803561

Printed in China

10 9 8 7 6 5 4 3 2 1

Thank you so much for choosing to invest time in my book
and its pages. As an artist, I frequently find myself doodling
to release stress and get my creative juices flowing again.
Never in a million years could I have imagined people using
my artwork to do the same. It's such an honor to be able
to share my artwork with you. I cannot wait to see how you
transform it and customize it to make it completely your own.
If you decide to post your work to
social media, be sure to use
#heydayofcoloring so that I can see!

Xo, Alli

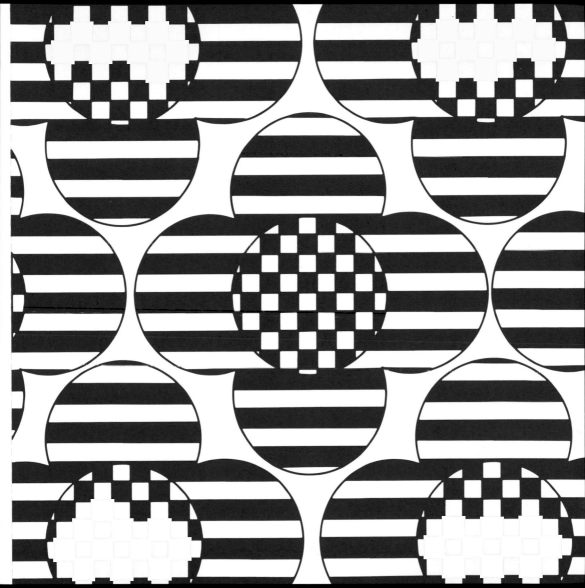

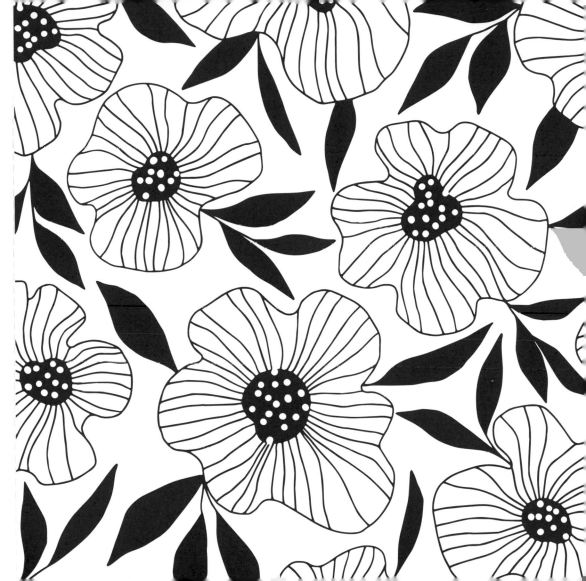

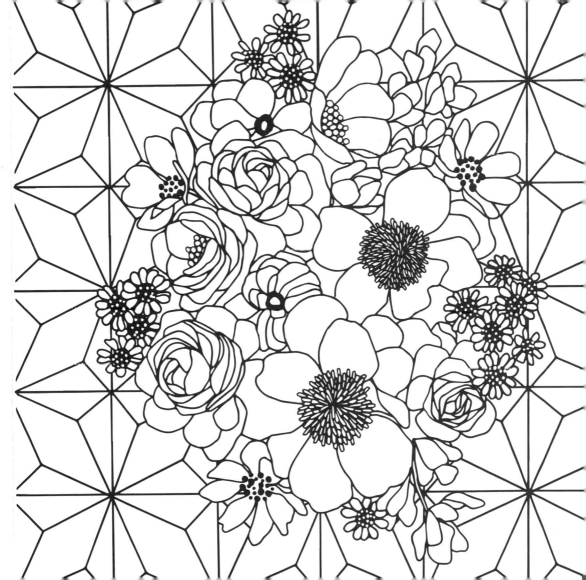

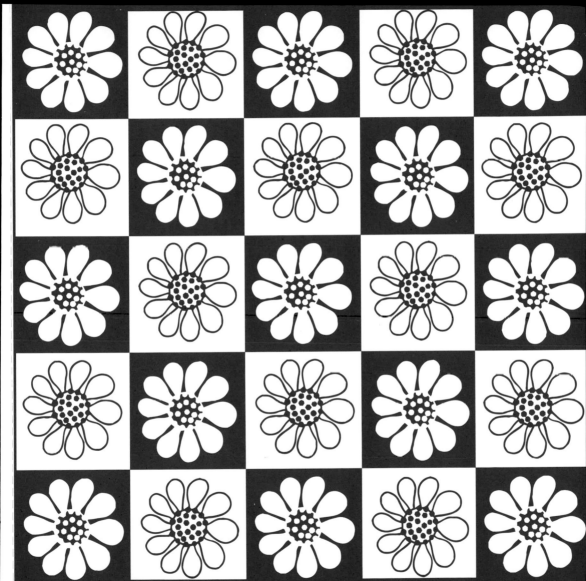

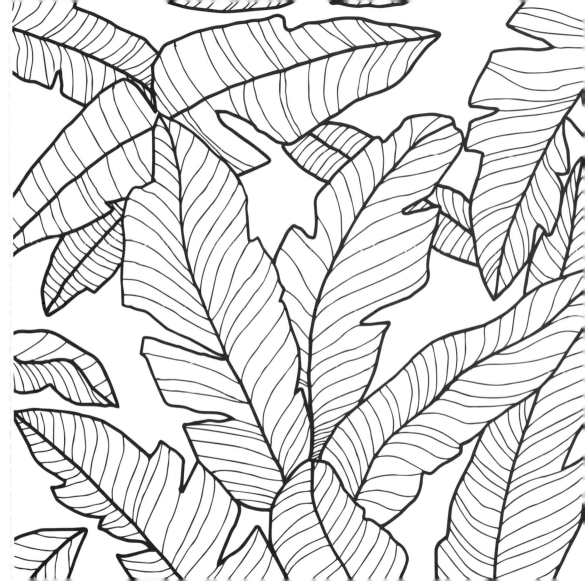

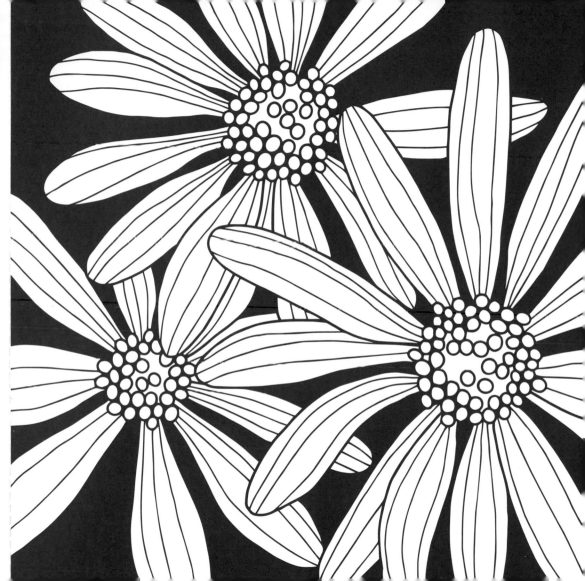

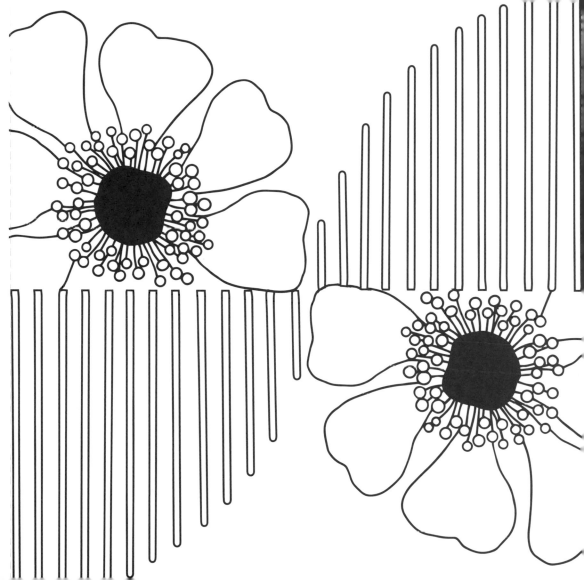

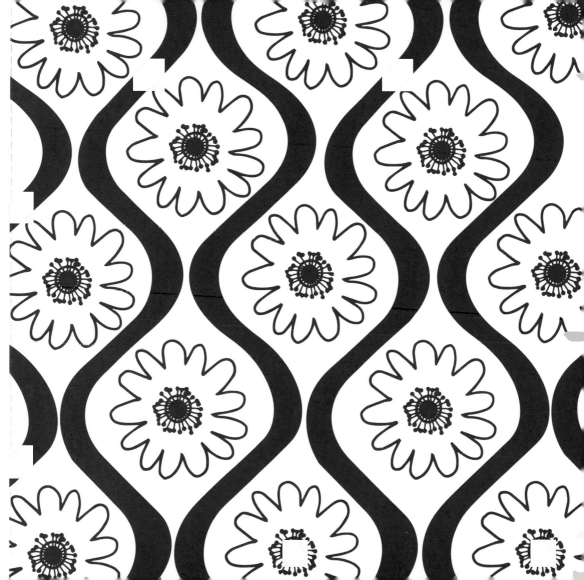

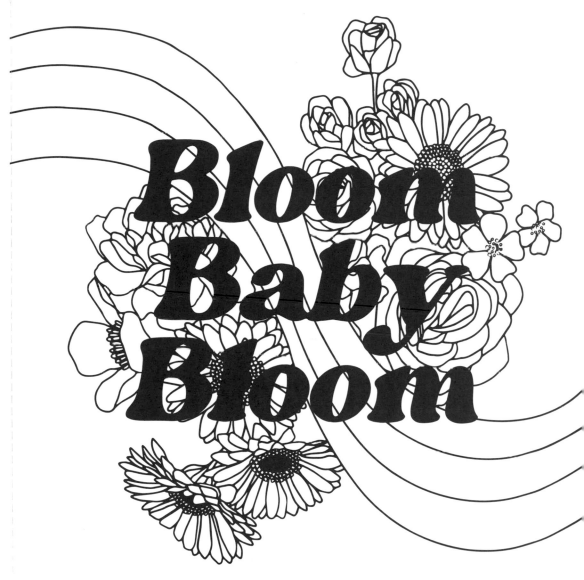

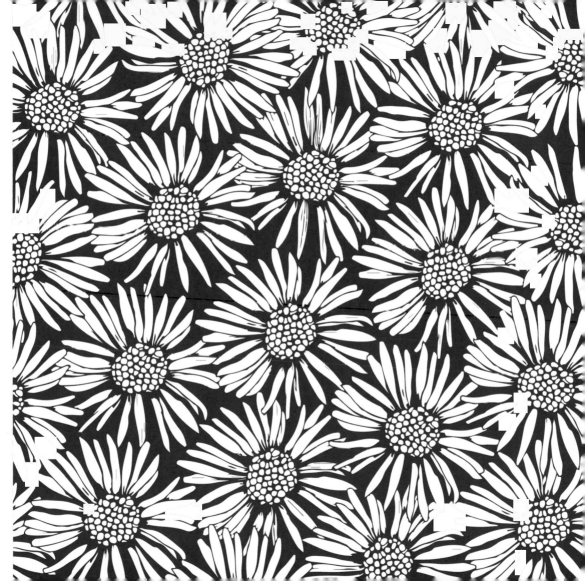

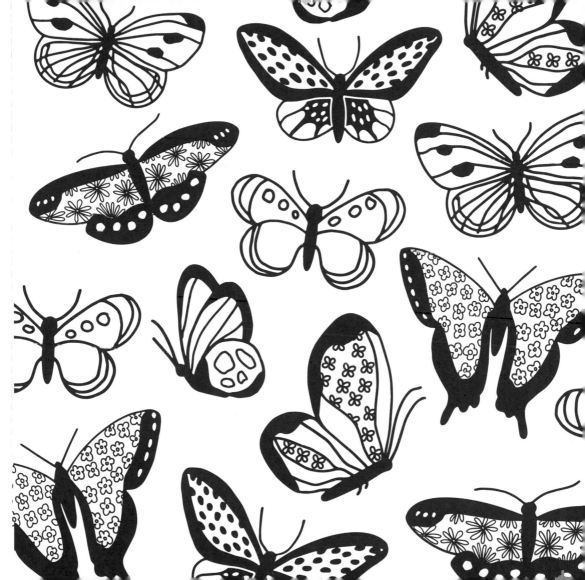

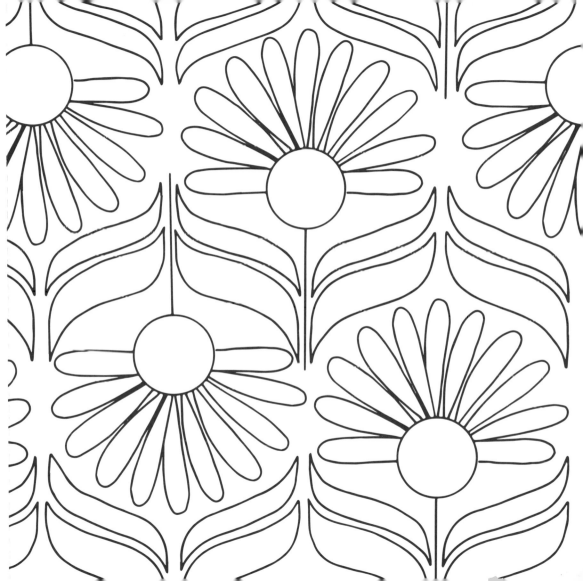

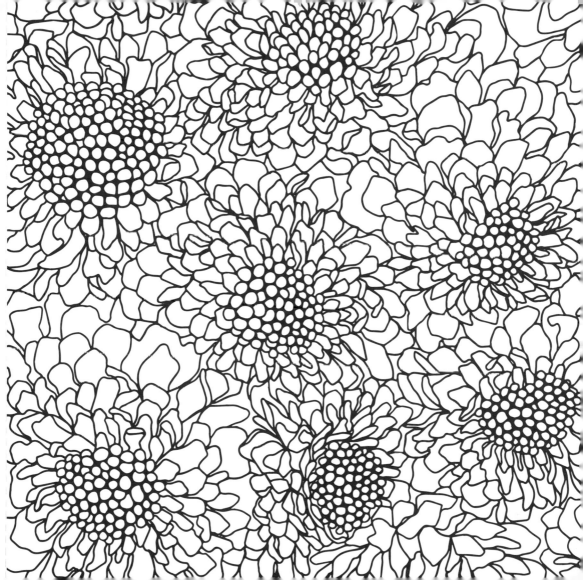

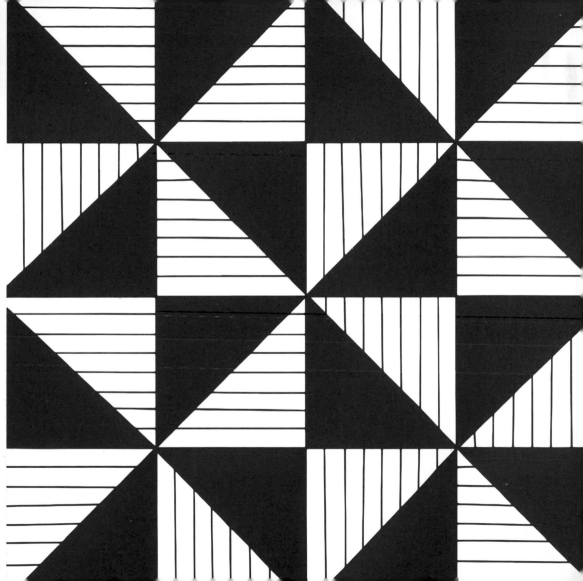

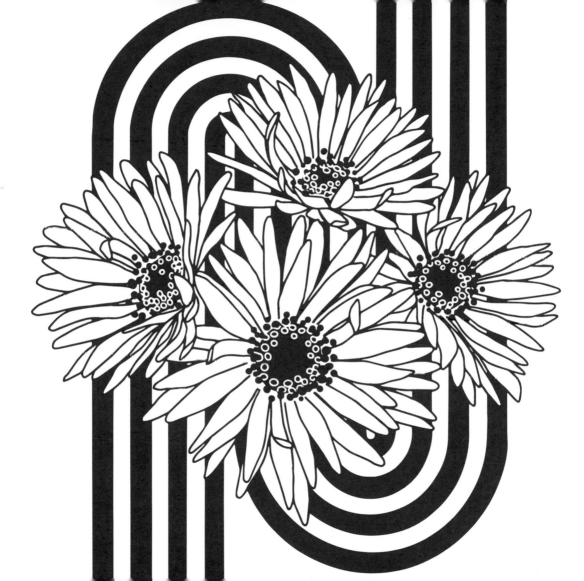

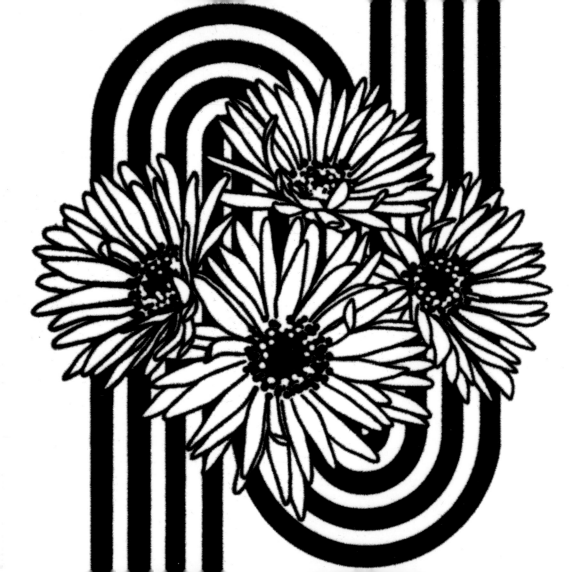

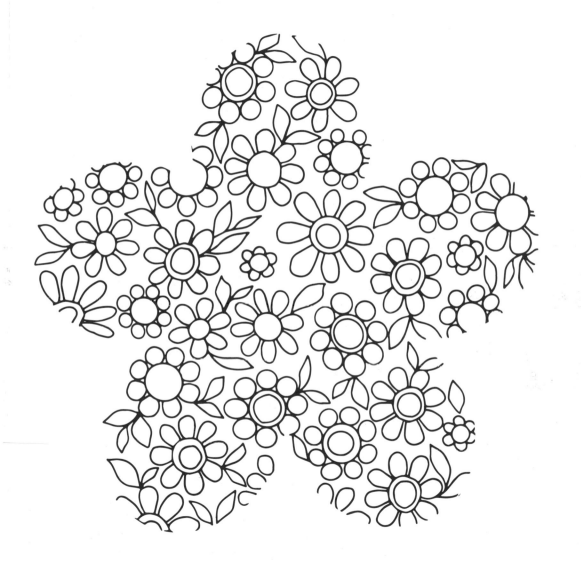

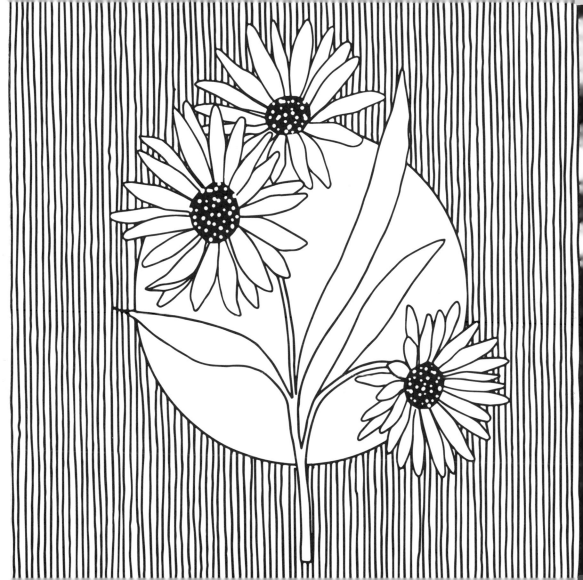

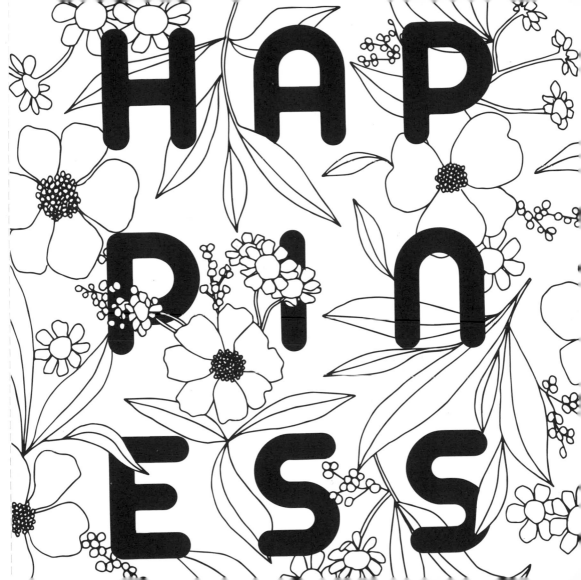

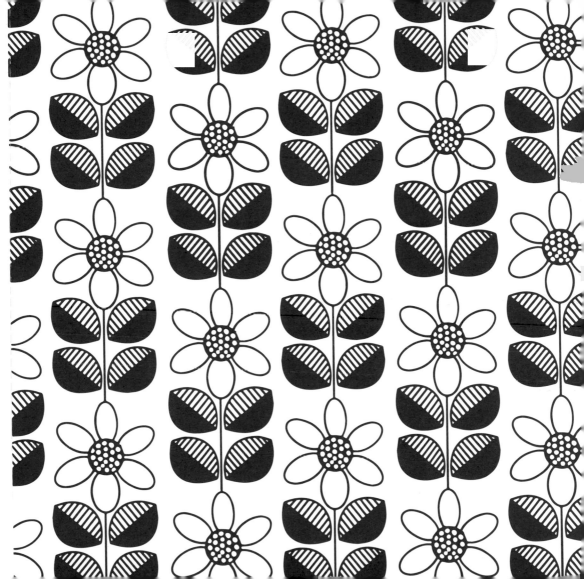

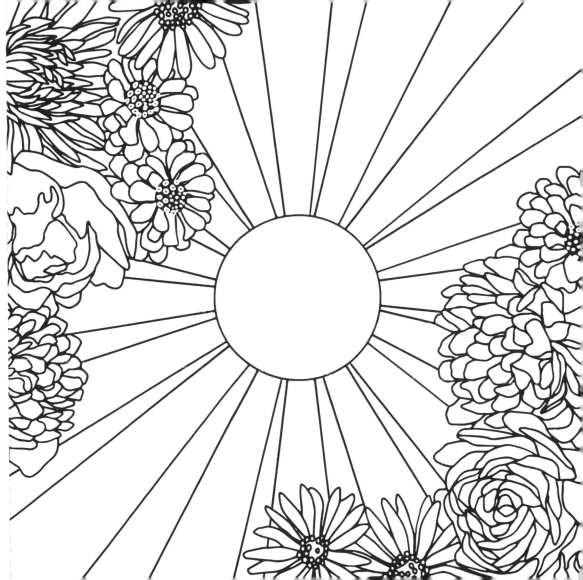

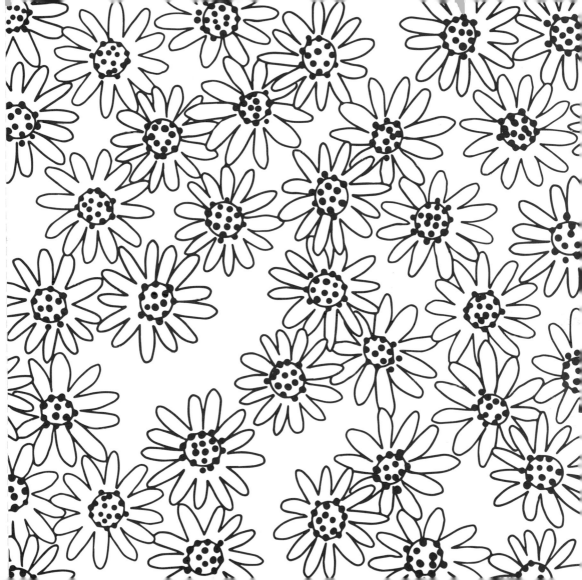

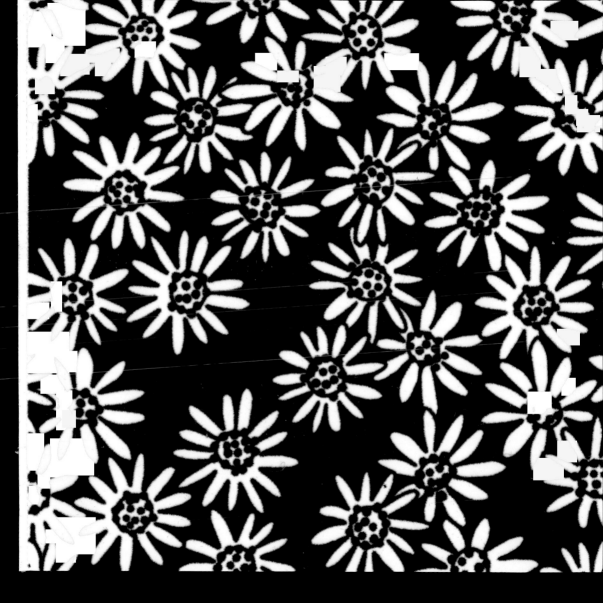

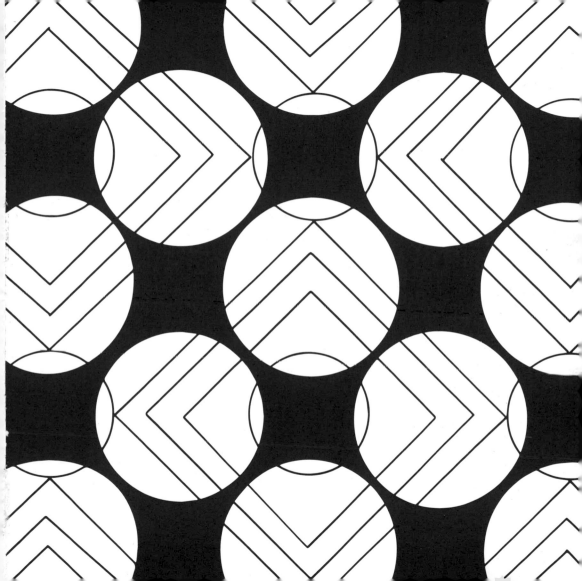

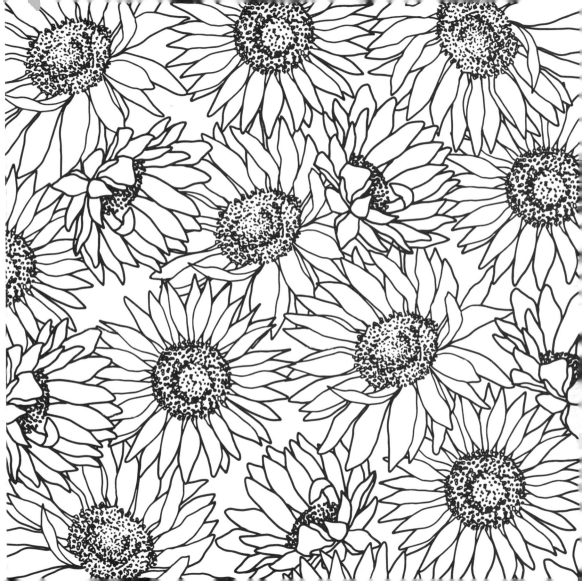

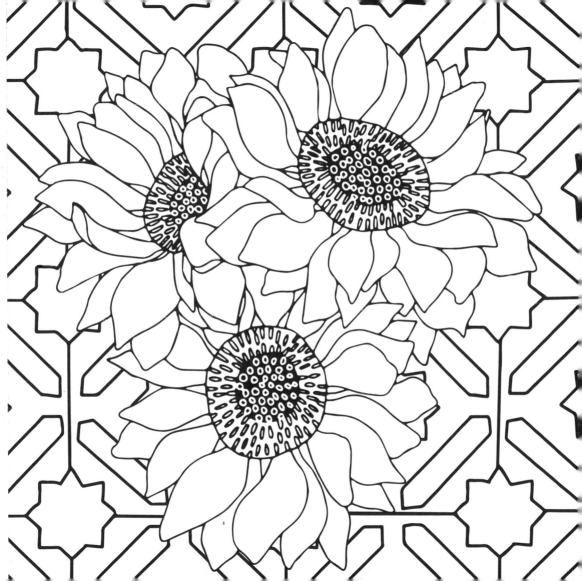

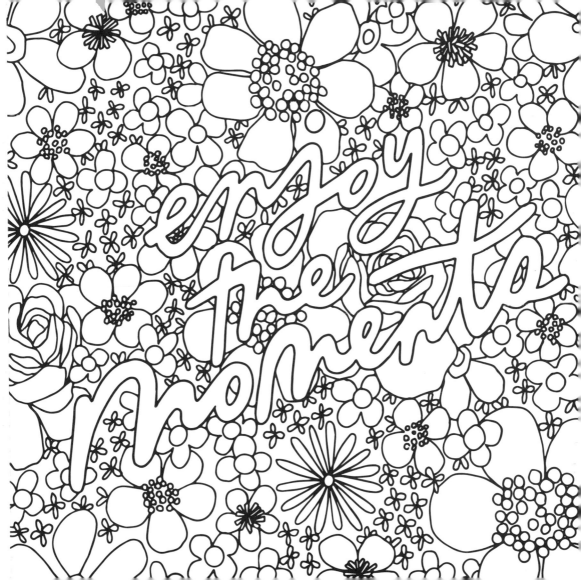

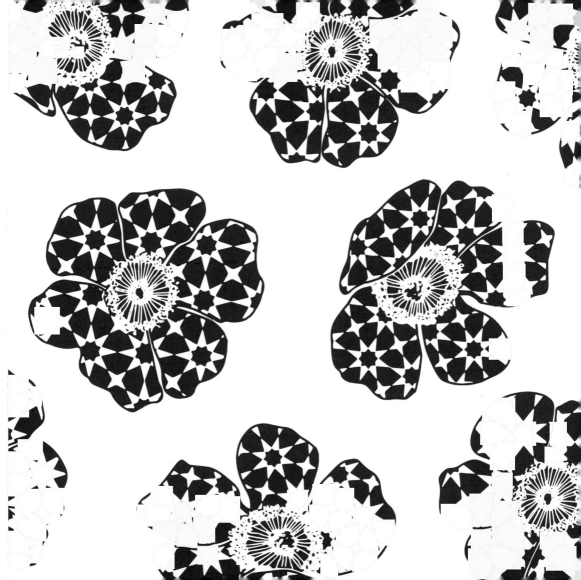

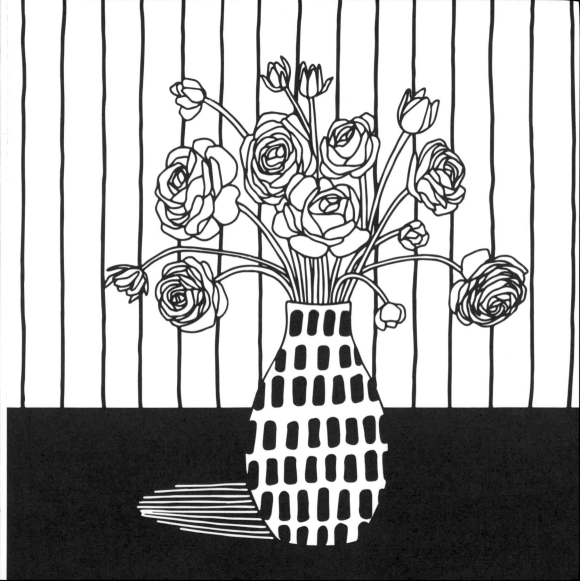

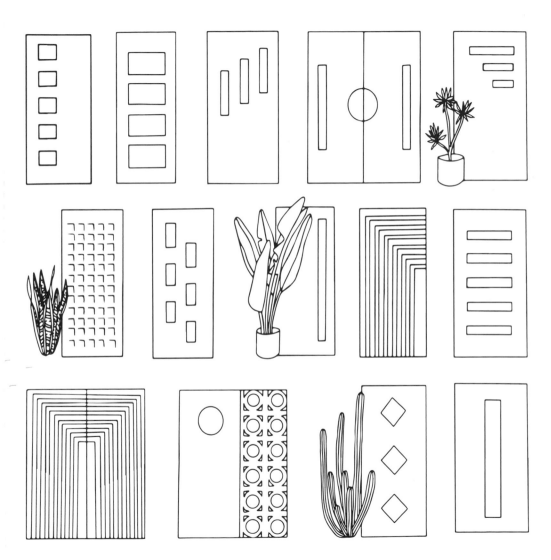

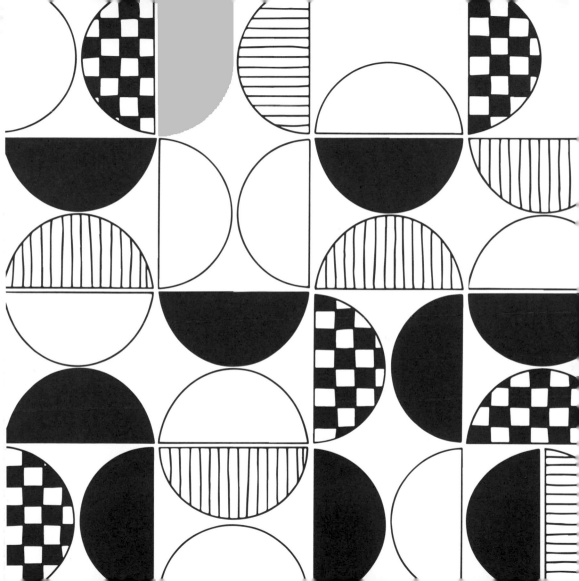

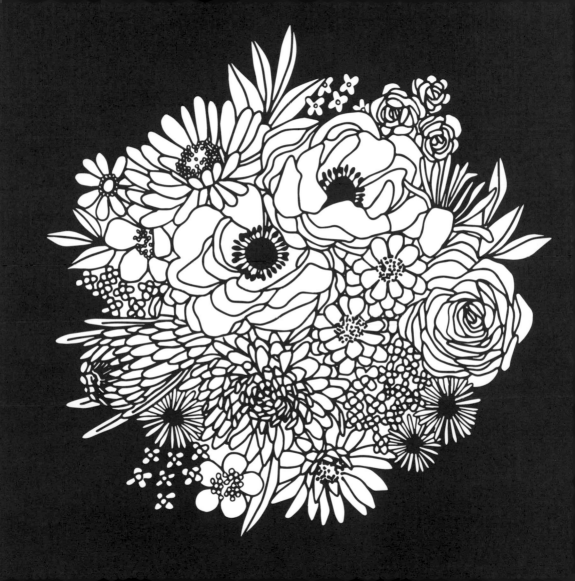

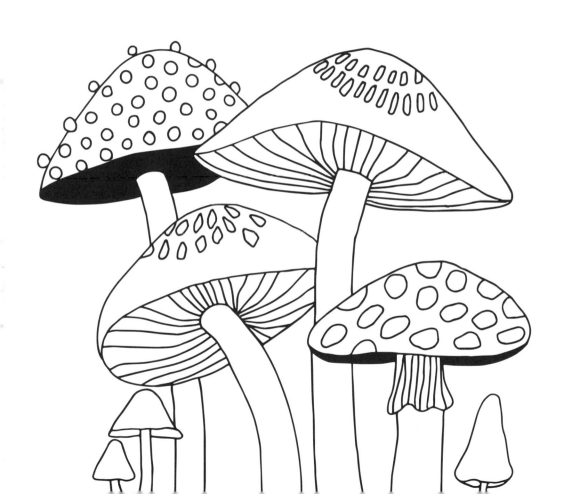

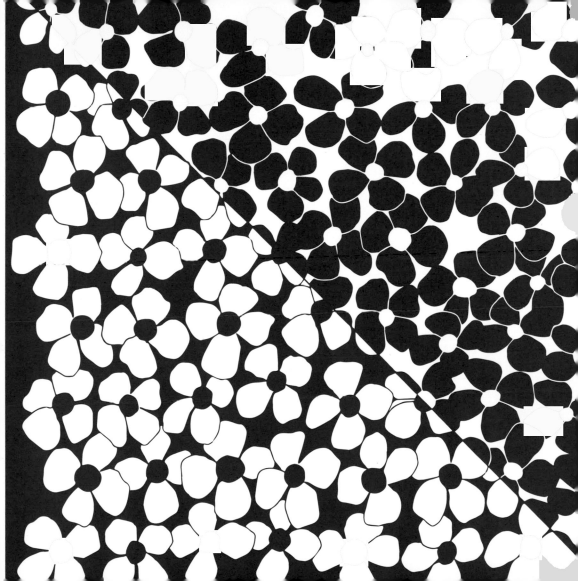

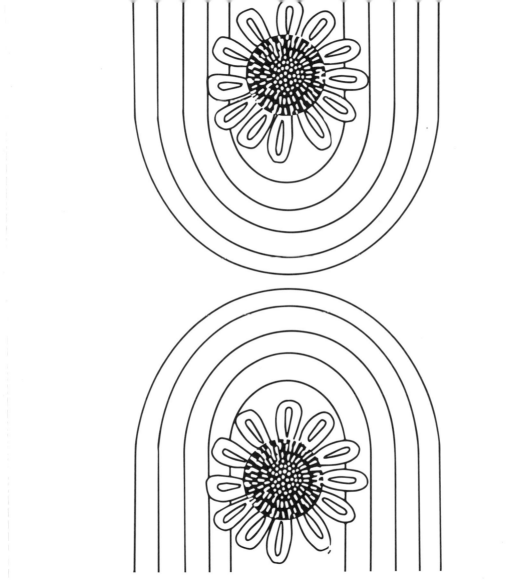

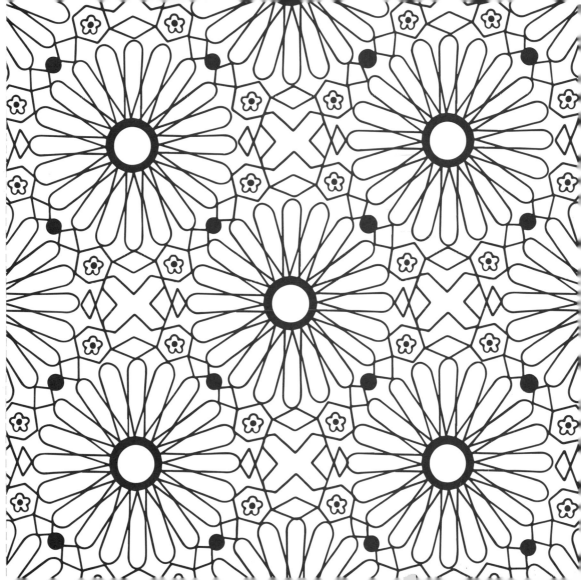

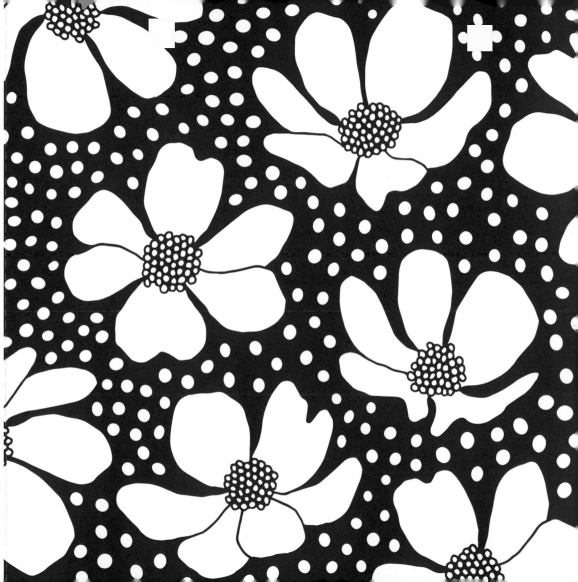

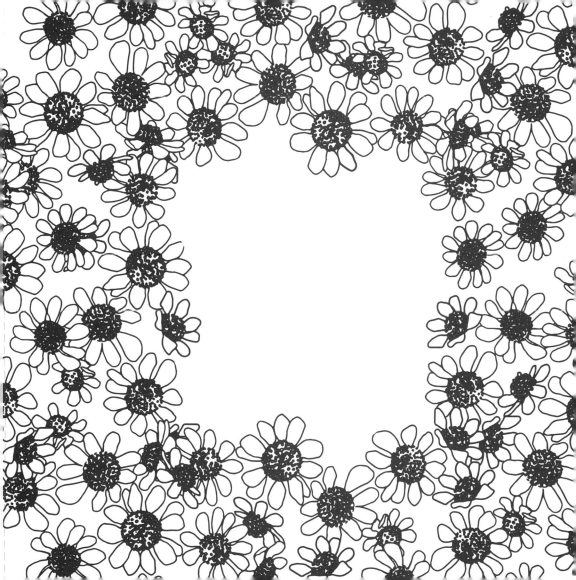

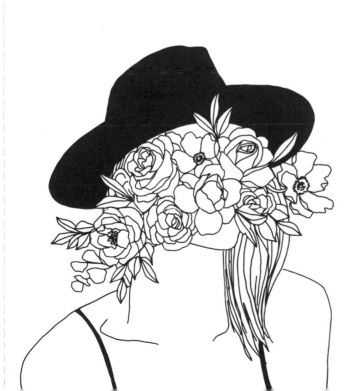

Alli Koch is the hands and heart behind Alli K Design. She has created a name for herself using her unique drawing style and staple black-and-white color palette. As a visual artist and illustrator, Alli is on a mission to build confidence in others. This has led her to publish multiple books: *How to Draw Modern Florals*, *Florals by Hand*, and her how-to-draw books for kids. She also records a weekly podcast with her dad called "Breakfast with Sis." When she is not out painting murals around her hometown of Dallas, TX, you can find Alli in her studio drinking sweet tea and cuddling with her cats. To find out more about Alli and her work, visit www.AlliKDesign.com